Bags

Cover: *Crocodilus niloticus* skin, smooth finish.
Courtesy Tanneries des Cuirs d'Indochine et de Madagascar-Roggwiller, Paris.

© 2004 Assouline Publishing for the present edition
601 West 26th Street, 18th floor
New York, NY 10001, USA
Tel.: 212 989-6810 Fax: 212 647-0005
www.assouline.com

First published by Editions Assouline, Paris, France.

Translated from the French by Adele Kudish.

Color separation: Gravor (Switzerland)
Printed by Grafiche Milani (Italy)

ISBN: 2 84323 453 0

Bags

BÉRÉNICE GEOFFROY-SCHNEITER

ASSOULINE

For my mother, who adores them,
For my daughter, who designs them,
For Véronique P., who manufactures them,
For Guénaëlle H., who presents me with them…

*"Women's handbags certainly were the only objects
that resisted mechanical improvement over the ages."*
Isaac Asimov, *The Caves of Steel*.

Carryall, tote, alms purse, compact, minaudiere, key purse, wallet, tote, basket, bolster, satchel, clutch bag, vanity, drawstring bag, reticule, mesh bag.... Laundry bag, knitting bag, travel bag, handbag, backpack, shoulder bag, evening bag, object bag, toy bag, gem bag.... Bags made of paper, plastic, cardboard, denim, metal, wicker, bamboo, feathers, fur, pearls, silk.... Alligator, python, ostrich, elephant, calfskin, vachette, pigskin, shagreen bags... New Guinean bag, Zulu bag, Eskimo bag, Chinese bag, Indian bag, hippie bag, fantasy bag, "retro" bag, preppy bag.... And also the bags that are mono-grammed, fringed, sequined, customized, copied....

The world seems to have given in to the craziness of the bag. Utilitarian or frivolous, cheap or precious, practical or uncomfort-able, classical or extravagant, it is the one accessory that crystal-lizes a woman's aspirations and fantasies: seduction, power, mobil-ity, wealth, prestige, vanity.... A miniature home, an umbilical cord connecting us with our "ego," the bag has become an unavoidable

sign of social status and fashion consciousness. It is the first sign of style, of "tribe," of personality, and of social class. But on a deeper level it symbolizes the feminine world and all its contradictions. Whether dangling on the shoulder or from the hand, stuck between the shoulder blades, twisted around the wrist, belted around the hips, or dancing on the belly, a woman's bag simultaneously frees and holds her. A mandatory rite of passage for any contemporary designer, it is the perfect subject for the imagination, an ideal object to show one's originality. Vivienne Westwood, the eccentric British designer, recently proved this once again by creating a "fake fanny" bag. A portable desk, a substitute "security blanket," an alcove filled with secrets, or a miniature boudoir, the bag is a true fetish of modern times.

In his most famous work, *The Interpretation of Dreams,* Freud compared any hollow object to the female sex. To associate the uterus or the weak sex to the bag requires only one leap of the imagination, one that has been happily taken by some psychoanalysts and admen in recent years. Just look at those shiny posters in which two rivals, displaying a ferocious sexuality, fight over a handbag. The theft of the bag as an abomination, not to say "castration," is communicated by a campaign launched by Louis Vuitton featuring a young woman—looking very much like a little girl—who swings a scary-looking pair of pruning shears. It is not by chance that Alfred Hitchcock himself filled his films with the fascinating presence of this kind of erotic and ambiguous accessory: lipsticks, scissors, hats, stiletto heels, and, of course, hand-

bags. Instruments of impenetrable desire, bewitching, and potentially murderous, they are often the signature of the crime, the trigger of all fantasies.

In short, the bag is unavoidable, ever present, universal, obsessive, sexual. Inseparable from the woman, it is a symbol of belonging and an extension of the self. Wearing it conditions both a woman's attitude and her movement; miniature or precious, it helps hand gestures; large or loud, it causes shoulder movements and provokes unrestricted poses. As to the backpack, that emblem of unisex youth that frees the hands, it invites a nomadic perception of the world and contributes to the general mobility that characterizes the new generation. A bag as a "time capsule," somewhere between a survival kit and a chest of drawers.

I t took centuries—millennia!—for humanity to conceive, accept, and tame this receptacle we baptized the "bag." As summarized, not without humor, by Geneviève and Gérard Picot in their "funny and impassioned history of the handbag": "Man fell into his own trap: loaded up with what he imagined and created, he finds himself facing the imperious and painful reality of having to lug around what he thinks is vital. Whether the load is heavy, minimal or large, common or precious, whether the scene takes place in the mists of time or in the present, his travel from

one point to another requires an envelope. A resigned porter, man carries, and the bag came out of this fate." Before achieving glory and the status of indispensable accessory, this receptacle, which still does not have a true name, crossed a long period of purgatory, facing the competition of another container that proved to be a fearsome rival: the pocket. And the story of this rivalry will forever oscillate between what is hidden next to the skin, and what one exhibits out in the open.

Of course, the history of humankind teaches us that the first bags were far from being cute powder compacts or elegant key purses. In the Neolithic period, the beginnings of weaving gave birth to a primitive receptacle: a rudimentary bundle made of a rough piece of skin twisted around a stick. Many centuries later, the Hittites, the Carthaginians, and the Etruscans surpassed each other in ingenuity to decipher the alchemy of tanning. But it was the Greeks and the Romans who are credited with the paternity of the first "bags" that deserve this name: the *kôrukos* or bundle made of gut, the *saccus scorteus* or the ancestor of the backpack, the *bugla* or tote. It is true that in the remote times of Ulysses and Penelope, the privileges of unrestricted movement were reserved for men only, and therefore this accessory was strictly worn by them. Women used a small mesh bag or *reticulum,* which achieved a new prominence later on. Wasn't the name *réticule* given to the first handbag proudly toted by the elegant women of the Directoire in 18th century France?

Active, hard-working, and in many ways more emancipated, the women of the Middle Ages soon started to wear at their waist a

band—either circular or rectangular in shape—from which a multitude of leather or canvas pouches hung for the purpose of carrying small objects and money. Even though they were attached to a garment, these receptacles constitute, to a certain extent, one of the first attempts to develop a "container bag." Riding a donkey or a camel, but most often on foot, pilgrims and mystics soon traveled the roads of the Orient and Occident, carrying on their shoulder a sack that was to have an important future: the tote. At the same time, Chinese and Japanese monks took the road of Buddhism in the opposite direction, to the West, with their backs bent under a basket containing the sacred scrolls or *sutras*. It is amusing to recognize in this basket the ancestor of our backpack.

molded, tight, seen as highly erotic, the feminine and masculine garments of the 11th century were adorned with countless little pouches tied at the waist by a belt or a chain, offering a multitude of storage spaces. Mid-way between the pouch and the bag, the alms purse—which, as its name indicates, was originally designed to keep the money reserved for alms—quickly became an object of attraction. Embroidered with gold and silk, adorned with scenes of gallantry or of love, this clothing accessory shares with our current handbag a precious nature...and a certain amount of disorder! One can find in them, in a messy pile, writing tablets, keys, but also combs, jew-

els, scissors, tweezers....

Worn at the waist, the wallet also allowed itself all sorts of refinements. Whether made of velvet or chamois and inlaid with gold or silver, it had a secret clasp—not unlike the lock to a safe! The symbolism and preciousness of the jewel-bag was not very long in coming. To be convinced, just look at those jewels of the Renaissance with their swirls of embroidery whose luxury and ostentatious sensuality are among the first signs of the exaltation of individuality and of fashion's first steps.

And then, in the 16th century, a very clever accessory emerged in Venice and then in France: the muff. As aptly summarized by Geneviève and Gérard Picot: "With or without inner pockets, unctuous tunnel, or closed circuit, it is a true cornucopia for women and men. It was a tiny cabinet capable of containing handkerchief, pill box, powder compact, a box for fake beauty marks, fan, cigarette box, and coin purse, which often served as a letter box. This bag was inherently sensuous with its soft interior and clammy warmth. The hand hides and travels in this small, warm, plushy nest, and whether or not it seeks in it a sweet note, it finds the voluptuous contact of the fur." Long and narrow in the 17th century, this "bag substitute" reached such extravagant dimensions in the next century that the most flamboyant women even carried their dogs in them! At the same time, freely dancing around the waist were small personal objects revealed for all to see without the slightest shame, resulting in a strange balancing act that chose to exhibit or hide, to wear outside or plunge in the darkness of the garment. The

coquettes chose to hide in the folds of their overlapping skirts and the froufrou of their lace a multitude of small pockets held around the waist by a belt. These were "strange and clandestine bags" that swung sensually between the skirt and the underskirt, and which one reached by a gesture that was as furtive as it was discreet.

i n a growing desire for refinement, the 17th and the 18th centuries multiplied again the pockets and belongings joggling at the waist, but also on the thighs and the hips: chatelaines swaying with the rhythm of the walk, fans, mirrors, and salt bottles suspended by a hook at the waist. Made of silk, velvet, or embroidered canvas, the pouches were perfect for all sorts of uses: perfume bags were filled with odorous sachets and aromatic essences; game bags contained cards, dice, and chips; wedding pouches were embroidered with flamboyant hearts or tender Cupids. One of the most famous courtesans went so far as to lend her name to something that already heralded the promise of a bag: the "Pompadour." Wound around the wrist by a ribbon, it contained everything a woman of the court needed to possess: a lace hankie, a bottle of salts and a journal. It was as if the desire for a handbag—and the desire for autonomy and freedom that goes with it— was clearly becoming more and more pressing.

It was around 1800 that the first "handbag" worthy of the name

made its appearance. Gone were the ample skirts of the Ancien Régime, and the atrocities of the Great Terror were forgotten! This was a time for insouciance, lightness, hedonism, and frivolity. As a reflection of this wave of gayety and madness, the female body liberated itself from its constraints and immersed itself in sheer muslin and chiffon. As pockets disappeared silhouettes became airy, with long lines, transforming coquettes into ethereal vestals named "Diana," "Minerva," or "Ceres."

It was in this euphoric context of the liberation of manners and spirits that the obligatory accessory of these belles was born: a small bag made of netting, baptized the *réticule*, in reference to the *reticulum* of the Roman ladies who carried it nearly 2,000 years earlier. From "reticule" to "ridicule," the play on words was too easy not to be attempted. And the detractors of this new "female toy" stigmatized these "shameless women" who insulted good manners by exhibiting their "pockets" in broad daylight. But who cares about these spoilsports! The reticule achieved full autonomy, ostentatiously swinging at knee height.

Rounded, triangular, hexagonal, or octagonal, enhanced with embroidery or other adornments, it was a lady's indispensable companion, and held love letters, bottles of perfume or salts, not to mention the first cosmetics to finally leave the sacrosanct dressing table. But, soon to be tangled up in her contradictions and her corset, the early 19th century woman still hesitated between emancipation and seduction. Now amazon, now odalisque, her breasts pointed forward, her back arched, like a question mark on the

brink of tipping over.

Muffs, parasols, and ballooning dresses became the declared enemies of a bag that was temporarily set aside. Or if worn at all, the bag had to be small, not to say diminutive, like the luxurious, magnificently adorned chatelaines worn at the belt, ancestors of the evening bag or jewel-bag. Indeed there was no need to burden oneself with the superfluous—a man, a husband, a lover, or simply a servant was called upon to transport heavy or voluminous objects. Money, keys? What for? A "proper" lady had her purchases delivered to her home where a valet was always ready to open the doors of her house for her. So it is necessary to wait for the dawn of the 19th century—confined and bourgeois—to finally see the triumph of the handbag, which from then has become an obligatory accessory.

Suffragettes, women lawyers, shop girls, nannies, typists, but also—just like the men—journalists, writers, speakers, travelers. On the verge of the 20th century, women emancipated themselves, freed themselves, became "vulgar." They smoked, drove cars, traveled, took walks, went shopping, fixed their makeup in public, seduced, played sports, carried papers and notes, wallets and checkbooks, right along with their combs and mirrors.

Undoubtedly, these Proustian silhouettes par excellence, whores and fashionable women, continue to parade in boudoirs and salons, dragging their boredom to the racetracks of Deauville or Auteuil.

But these Odettes, and other duchesses of Guermantes, were a disappearing breed. Women became pioneers, abandoned the reticule and the embroidered purse, trading the knitting bag for the travel bag. A happy compromise between the two—with the volume of the first, the usefulness of the second—the handbag was living its first hours of glory. Founded in Paris in 1854, the Vuitton house understood the handbag well, and offered a line of seven huge models, ranging from twenty to fifty centimeters in width. Inspired by the house's line of suitcases, these handbags clearly show their utilitarian character. Created in 1932, the Noé bag owes its name to the fact that, originally, it was designed to hold five bottles of champagne. But the greatest success of the family is surely the famous "keepall," which, as its name indicates, is the perfect compromise between the small piece of luggage and the large handbag. However, it was necessary to wait until 1959, and the invention of a new technical process, for the model to adopt its famous monogram that, since 1896, has been the "label" of the house.

Decidedly practical, the bag, in the beginning of the 20th century, owed its successes to technical innovations and the invention of new materials. In 1918, Émile Hermès returned from Canada with a revolutionary process in his suitcase: forty meters of zipper (called "American fastener" at the time) until then used for explosive shell covers. This intuitive, modern man (it was the era of the automobile and the reign of speed so much praised in Fitzgerald's stories) immediately knew how this invention could be used. From the ancestral know-how of the prestigious firm (the Hermès had already been har-

ness and saddle makers for three generations) was soon born a whole series of hand-stitched bags, using two needles (the famous saddle stitching), whose shapes rival each other in elegance and sobriety: the valise bag in 1923, the car bag in 1925, the feeding bag, and especially the "little tall bag with two handles" that was to have a fabulous destiny. After starting out as a saddle bag in 1892, it was redesigned, then promoted as a handbag in 1935, it would ultimately be baptized the "Kelly" bag in 1956, when the divine American actress-turned-princess Grace of Monaco appeared on the cover of *Life* magazine carrying the now legendary model.

at the beginning of the 20th century, the handbag entered everyday life, but at first it was deliberately only functional. Created by leather goods manufacturers (a resolutely male profession) and not by couturiers, it was all about materials, utilizing the whole spectrum of available skins: dyed leather, reversed skins, buckskin, or tooled leather. Its usage was still dictated by the rules of etiquette. It was out of the question to carry the same bag for day and evening use. Several decades later, Christian Dior, the arbiter of good taste, recommended in his *Petit Dictionnaire de la mode* that "for morning, choose a very simple style; for evening, a smaller bag, and why not with a touch of fantasy."

Very quickly, women created their own rules and freed themselves

of any mandates by donning tailored suits that looked like uniforms and filling the positions left vacant by men. Now they could be seen in factories, offices, and hospitals, walking confidently, with a military air. One detail tells the whole story: more than any other accessory, the bag mirrored these profound changes. It was not by accident that it was two women—and important ones, to boot!—who turned the conventions on their head. "Sick and tired of holding my handbags and losing them, I stuck a strap on them and wore them slung across my shoulder," Coco Chanel, the high priestess of fashion, confided to her friend Claude Delay. The rest is history. "Borrowing" its functionality from the male universe, the "oracle of the Rue Cambon" transcended genre and metamorphosed the "military satchel" into a refined feminine version of the shoulder bag. While the first 1929 styles were made of black or navy jersey (their lining in red or blue grosgrain were reminiscent of the uniforms of young Gabrielle's childhood boarding school), consecration came a few decades later with the famous "2.55." Behind this cabalistic name (in which the two figures represent the month and year of its creation) we find, in fact, a fashion icon of the 20th century: a legendary leather or jersey bag with a quilted motif directly inspired by the checkered shirts of racetrack stable boys. A long gold chain interlaced with leather, a double "C" stitched on the lining, and a rectangular closure with a gold-plated lock, combine to form the inimitable silhouette of this great classic. As meticulously made on the outside as on the inside (here again the garnet lining would betray a childhood remembrance, the uniform of the boarding

school girl from Moulins), Mademoiselle's bag is there for every occasion. Three flap pockets prove it: the first in the shape of a tube for lipstick, the second zippered, and the third suitably baptized "secret" to receive love letters and other missives. It took, however, every bit of Karl Lagerfeld's creative enthusiasm, in the very early '80s, to do away with the upper crust image attributed to Chanel bags. Reissued again and again, in denim, in raffia, in foam, in sequins, in vinyl, gold tone, fluorescent, immense or tiny, it has since become a backpack, a fanny pack, a vanity case, a toy bag, and a gem bag, without losing any of its prestige, or the 180 or so operations necessary for its manufacture! As to its claimed "modernity," just look at the billboards to measure its popularity.

more imaginative and liberated, a friend of painters, poets, and musicians, another woman also jostled the masculine and icy world of the leather industry of her time: the provocative Elsa Schiaparelli. Although she too appeared as one of the first designers to create shoulder bags by the end of the '30s (strangely anticipating the satchel adopted en masse by French women forced to ride bicycles during the German occupation), this adopted Parisian blew a fantastical breeze into fashion that has rarely been equaled. From the highly celebrated "telephone" bag designed by Dali to the "birdcage" bag reminiscent of Magritte's *Modèle Rouge*, from the

"lamppost" bag equipped with a bulb to the "piano keyboard" bag or the "flower pot bag," the bag becomes a disconcerting poetic fetish. Wavering between toy and jewel, don't these witty constructions strangely anticipate the object bags of the latest fashions shows? The jam jar bag by Moschino, the country house bag by Lulu Guinness, the "Stiletto" bag in the shape of a spike heel designed by Rodolphe Ménudier for the house of Goyard, the "half-cup bra" bag by Jean-Paul Gaultier in which the shell is stitched like a bra. Even "old tech" is solicited, as illustrated by the deliciously "retro" audiocassette bags or vinyl disk bags in the latest Chanel shows, the TSF radio bag from Mulberry, or the particularly luxurious silver camera bag from Emmanuel Ungaro.

It is as if fashion was eternally beginning anew, constantly oscillating between sobriety and luxury, austerity and lack of inhibition, arrogant chic and frustration. In this regard, the bag is a mighty barometer recording the curves and counter-curves of these contradictory impulses. Now it is a geometric drawing, like the magnificent Art Deco purses which adopt the clean line of the rectangle or the perfection of the square; now it is a miniature jewel, like the ravishing minaudieres from the ateliers of Van Cleef, Cartier, or Mauboussin.

A barometer of cultural changes—the advent of unisex fashion, the proliferation of sports and leisure activities—and quick to adopt the technological innovations of its time—celluloid next to bakelite, soon replaced by Plexiglas, the use of plastic and synthetic fibers the bag has crossed the millennium tossed around by wars

and revolutions. Isn't its survival a small miracle in itself? Of course, its codes were struck down, as seen in the '60s by a new phenomenon: the handbag for men. Until now, briefcases, valises, and especially suit pockets had the privilege of transporting a man's personal items. Nowadays there are countless fanny packs, shoulder bags, backpacks, and other strap bags sported by the so-called "stronger" sex. In parallel, women cannot resist stealing glances at men and, ironically, find there the first bag of their childhood: the school satchel. The terrifying icon of these "wonder women," former British Prime Minister Margaret Thatcher, once called her handbag her "trusted man." Even Vivienne Westwood remembers it and will get photographed disguised as the Iron Lady, clutching her inseparable companion...

Critical of the dictates of fashion and attracted by what is somewhat ironically dubbed "world culture," parts of today's youth, returning to the styles of the '70s generation, have turned their backs on the "brand" trend, and have adopted fringed and crocheted bags representing a vague aesthetic of freedom. Goat hair bags, pseudo-*choukaras* made of embroidered leather, informal pouches made of a patchwork of all fabrics, reworked *kilims*, woven bags with Mexican or Peruvian motifs, bags with Indian mirrors, and even "Bollywood"-style plastic bags, sporting the silhouette of Ganesh, Shiva, or Vishnu as well as psy-

chedelic motifs.

At a time when the world trembles before terrorist threats and conflicts, one travels by proxy: in the street or on the catwalk. As Anne-Laure Quilleriet stresses in her work *The Leather Book:* "A few months after the historic September 11, 2001 attacks, collections presented their transformations of faraway places, from Afghan wool-lined hides and beaten leather to protective clothing that adapted the know-how of Inuits and Moroccan craftsmen alike to the dangers of asphalt. At Antik Batik and Marni, mandatory hangouts for the Bourgeois Bohemians analyzed in David Brooks's *Bobos in Paradise,* we find belts and bags, studded and decorated with small coins, that seem to have come direct from the souks of Marrakech. Córdoba leather, the hide embossed with stylized foliage patterns and flowers that had its heyday in the residences of the well-to-do in the 16th century, is enjoying a new lease on life in accessories and ready-to-wear from Fendi to Viviane Cazeneuve, who introduced it at Kenzo." In fact, this taste was also found in the shows of the great names of fashion and luxury who, like Christian Lacroix or John Galliano, did not hesitate to embellish the nomad roughness with a brilliance worthy of the *Thousand and One Nights.* As for Tom Ford, he imagined a 'Monbasa' bag, in which the 'primitive' strap is none other than a deer antler, found on the arm of every fashion editor in the summer of 2002.

Just as it is a powerful invitation to travel, the bag is also a marvelous time machine. Long reserved for those on small budgets and

collectors (or fetishists!), second-hand clothing and accessories have recently received a new aura, a second life. In their own way they offer a poetic answer to mass marketing and uniformity. But even here, elitism and snobbery are not absent in this crazy race to obtain historic pieces. Luxury brands like Prada and Dolce & Gabbana go so far as to devote to these "vintage" pieces a corner in New York, and a boutique in Milan. At the same time, the remaking of old styles flourishes, like at Gucci, which does not hesitate to dig into its archives to produce, in very limited numbers, bags inspired by the past "icons" of the house.

here, the prestige of the brand, elsewhere, the remembrance of stars who were closely associated with them. How could we forget that the most faithful patrons of Hermès were named Marlene Dietrich, Simone Signoret, and Grace Kelly. In addition to the "Kelly" bag mentioned earlier, the house on Rue du Faubourg-Saint-Honoré is proud to have created, in 1984, the "Birkin" bag for the British actress and singer, while renaming the mythical 1923 valise bag the "McPherson," in reference to the Australian supermodel. As to the "Lady Dior," it was named after the infatuation it elicited on Princess Diana in 1995. Made of canvas and leather for Jackie Kennedy and based on a prototype made of crocodile for Ingrid Bergman in Roberto Rosselini's

film *Europa 51*, the famous "Jackie" bag by Gucci remains undefeated and undefeatable. As for Chanel, one can easily say that the spirit of the "high priestess of the Rue Cambon" still inhabits the house. So, even though it is introduced as the "first of a whole new generation," the name of the "2005" bag is in keeping with "Mademoiselle's" personal mythology. The "2" indicates that it was designed in 1998, two years before the new millennium, the two "0"s refer to the international telephone code, while the "5" is an allusion to Coco Chanel's fetish.

But if there is a tyranny in this early part of the third millennium, it is undoubtedly the unbridled race for luxury and brands. Scores of women seem to say to each other: "we are of the same tribe" while exhibiting as trophies a monogrammed Vuitton, a timeless Chanel, an exuberant Dior, a classic Celine, a sexy Gucci, a minimalist Tod's, an "American" Coach, a preppy Lancel, a chic Cartier, a woven Bottega Veneta, a trendy Prada, or a Fendi "Baguette." And designer houses jump into a frenetic race to conquer the hearts of these "fashionistas" ready for any infidelity. The economic battle between the planetary powers that are LVMH and the Gucci Group is called "the luxury wars." It is a conflict waged through marketing coups and programmed successes, in which the bag is one of the main players. Is it not the obligatory accessory of all fashion "addicts"? Princesses, actresses, models and numerous glossy images imposing the dictates of a pre-defined taste...

A piece of luxury within arm's reach, an emblem of prestige and glory and a symbol of power and seduction, the bag remains a

"receptacle of vanities and neuroses" that a woman will not bear to be separated from. Is it not, in its own way, a piece of "nomadic architecture," a "sublimated home?" "Crazy, is what a woman believes she will become if she can't find her bag," summarized Pierre Daninos, not without humor, in his novel *Le Jacassin*.

I n Paris, the luxury store Colette knew what it was doing when it offered its wealthy customers the possibility of stamping their own image or images on their favorite bag. It is as if, between humor and narcissism, the bag has become a sort of self-portrait! Stigmatizing consumerism, Swiss artist Sylvie Fleury raised it to the rank of an art work: in 2002, her bronze sculpture *Kelly Bag* was auctioned off at Drouot in Paris for the modest amount of 18,000 euros. Which is quite a contemporary way to become a legend.

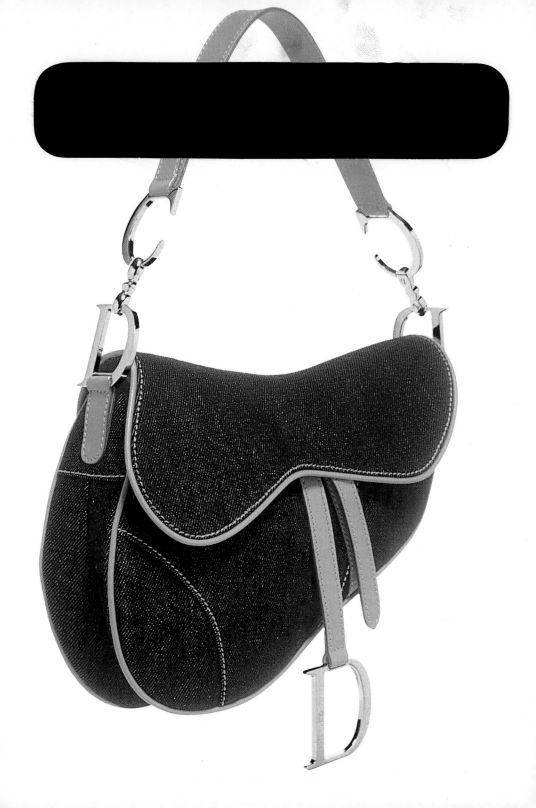

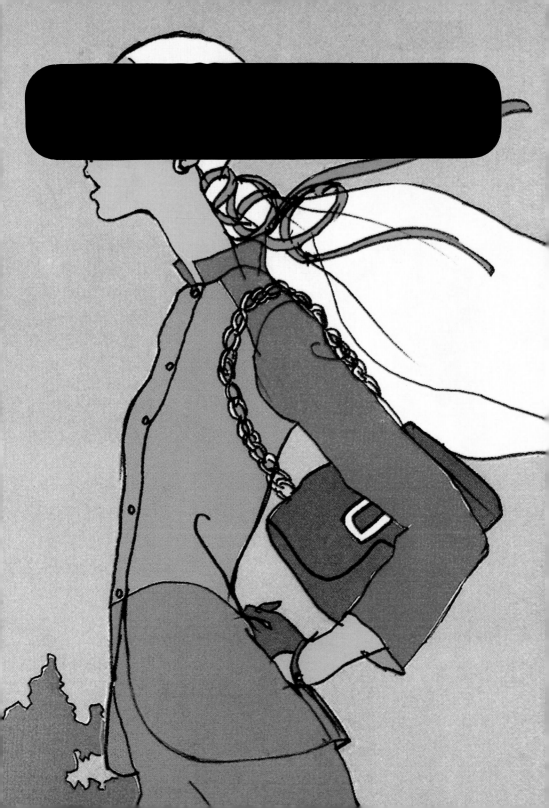

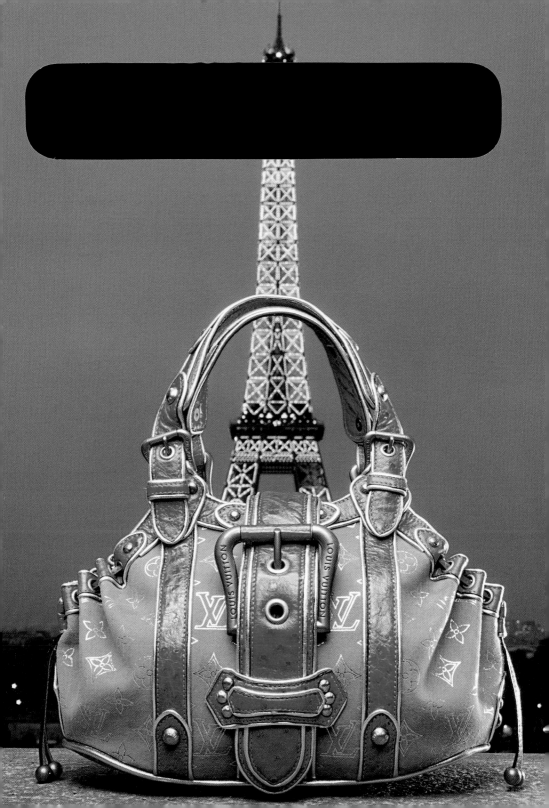

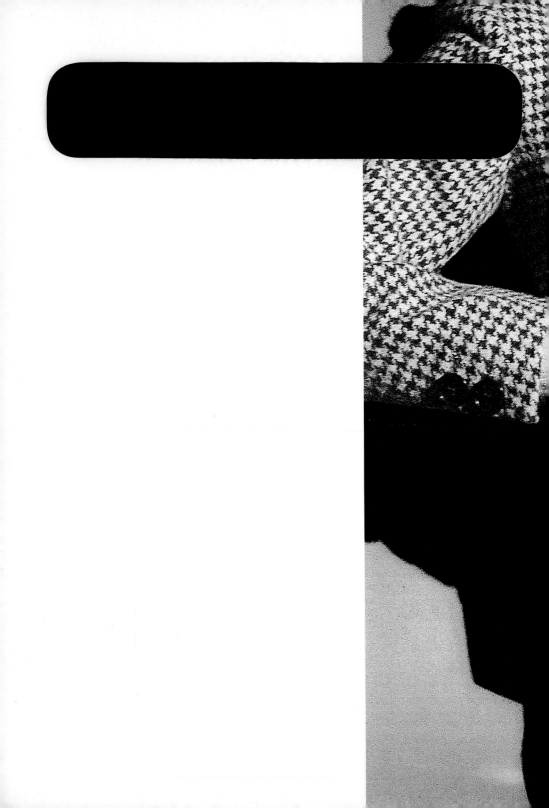

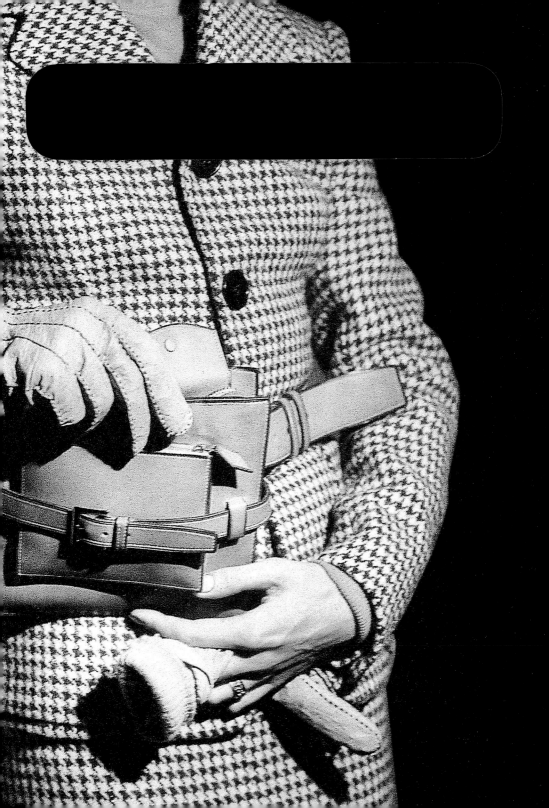

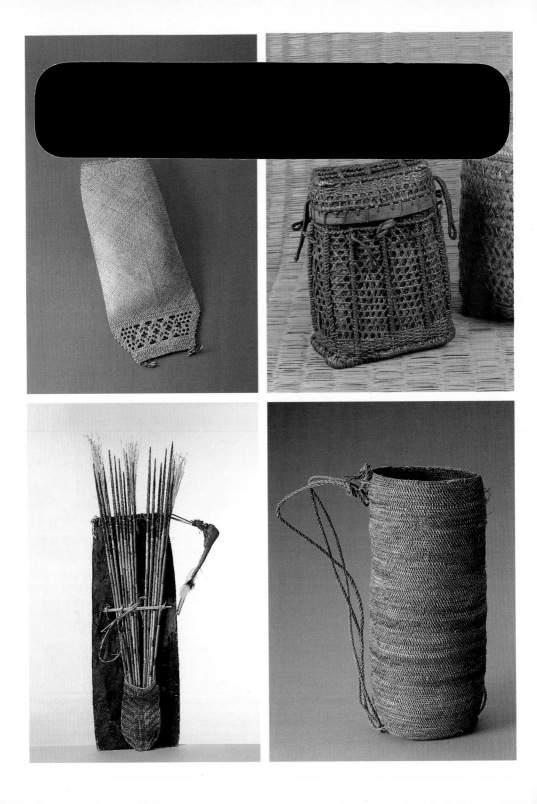

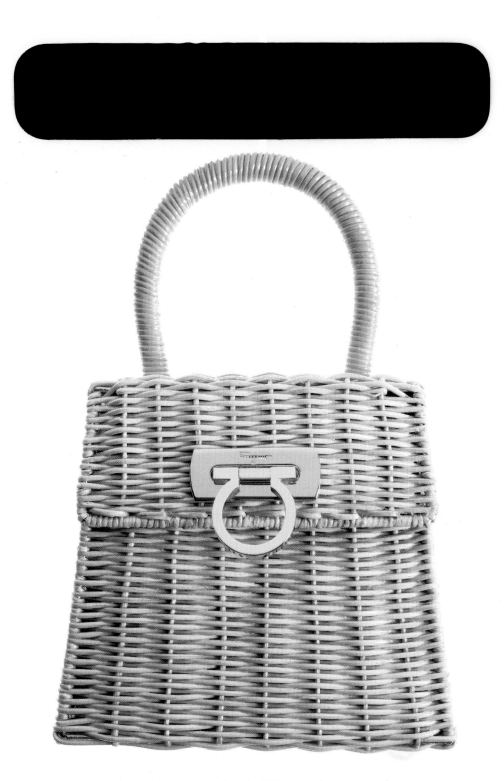

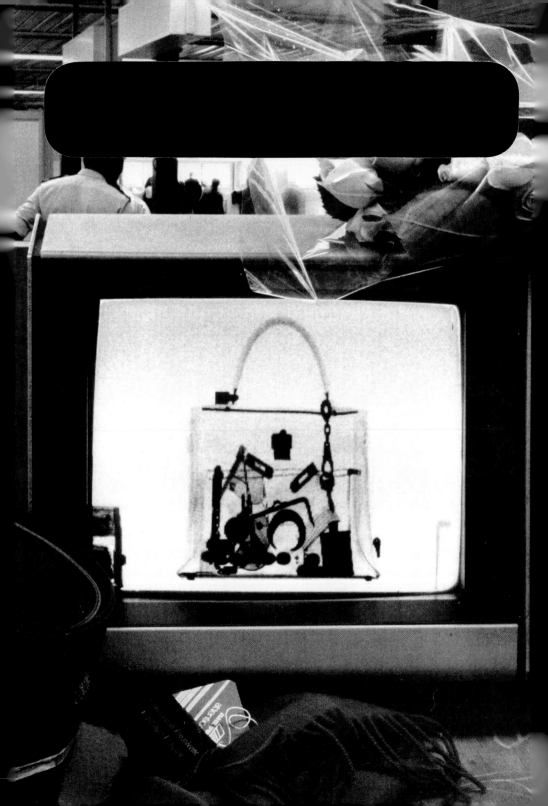

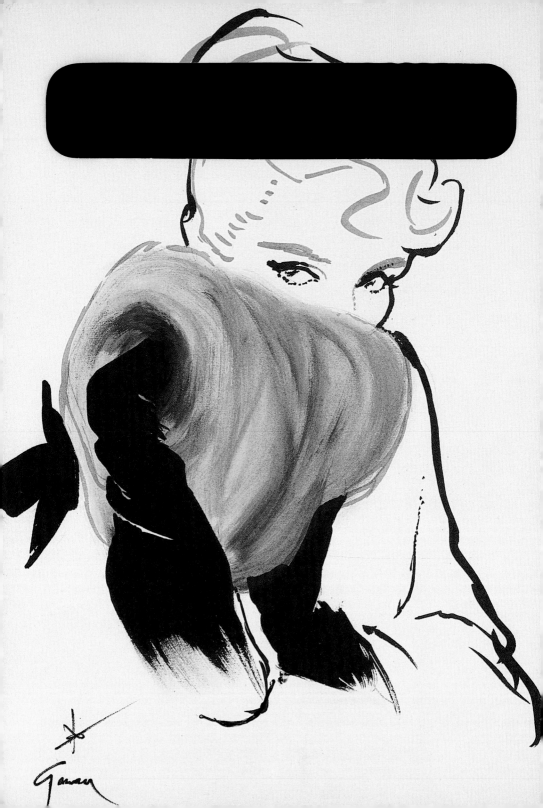

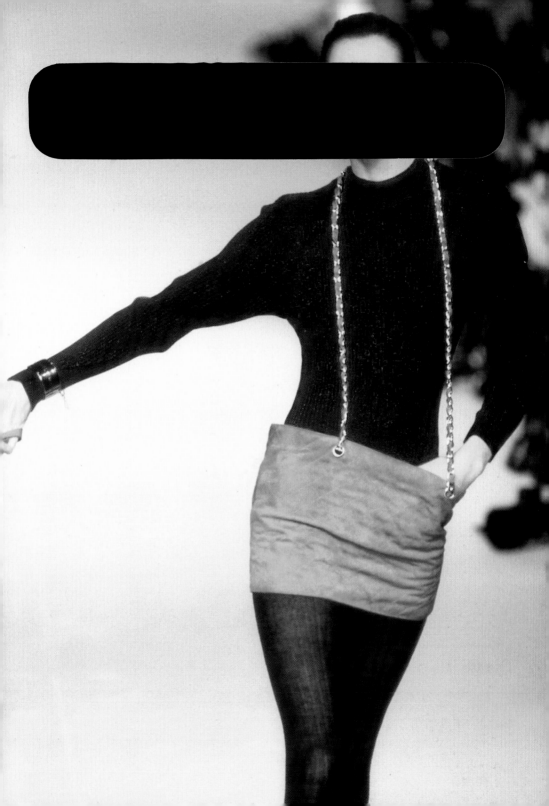

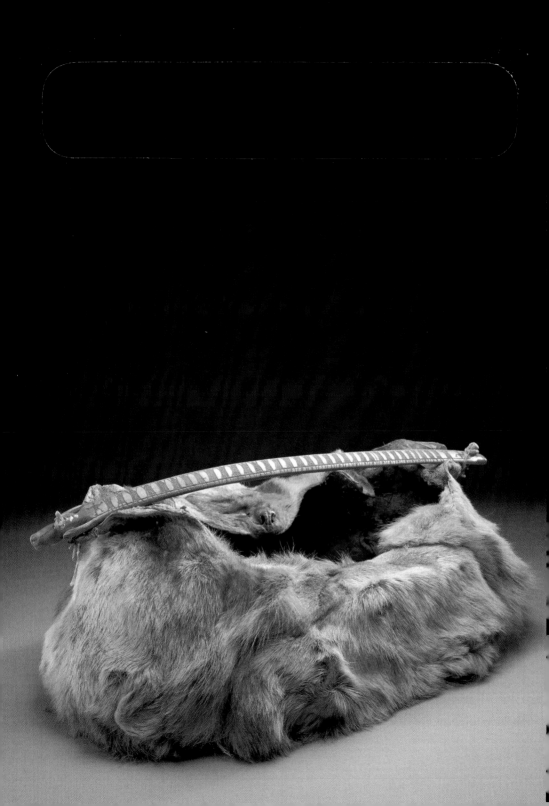

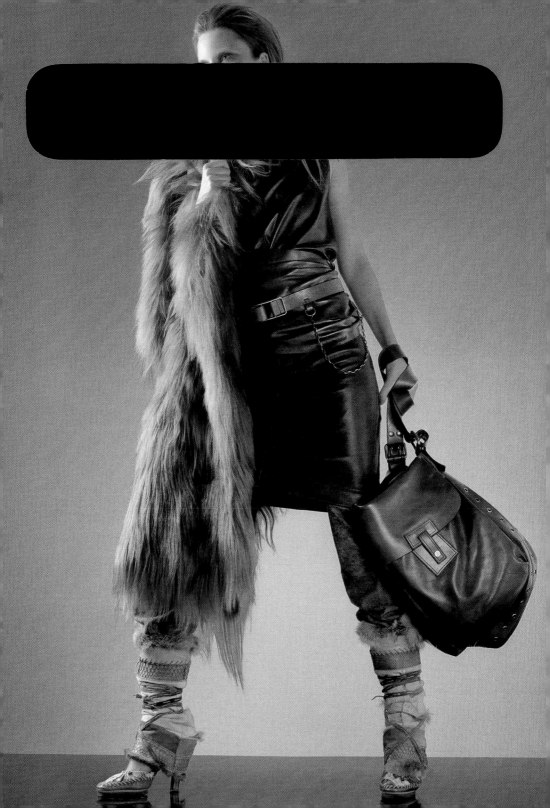

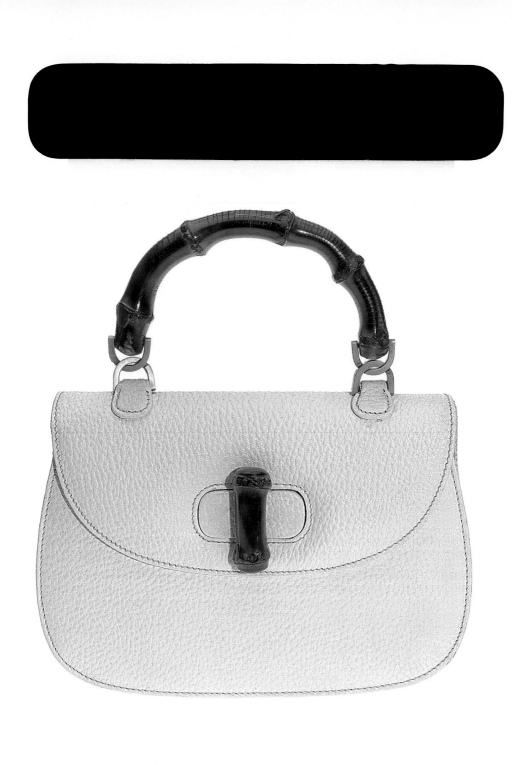

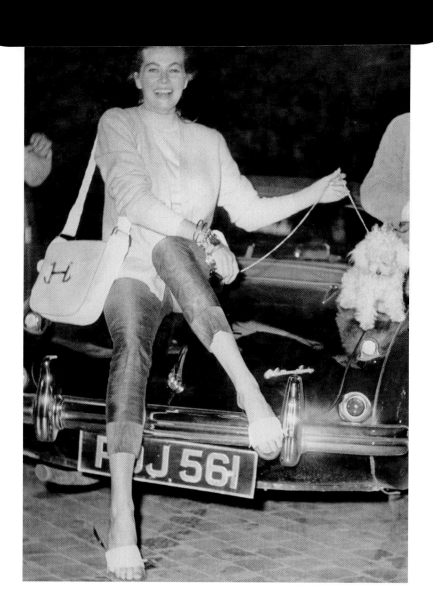

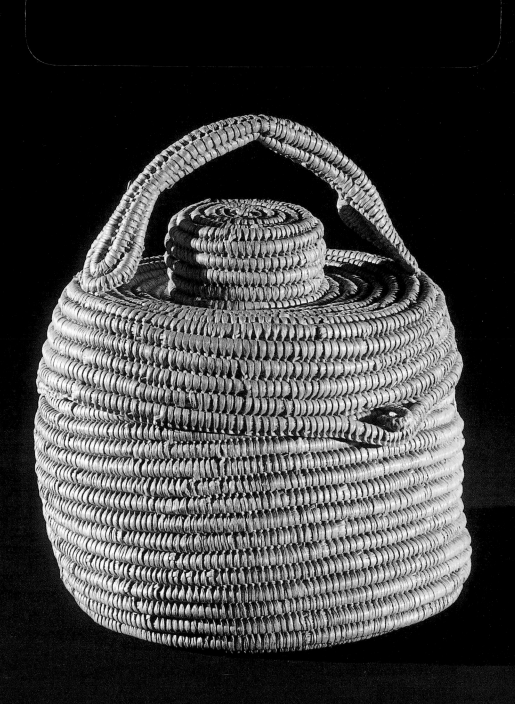

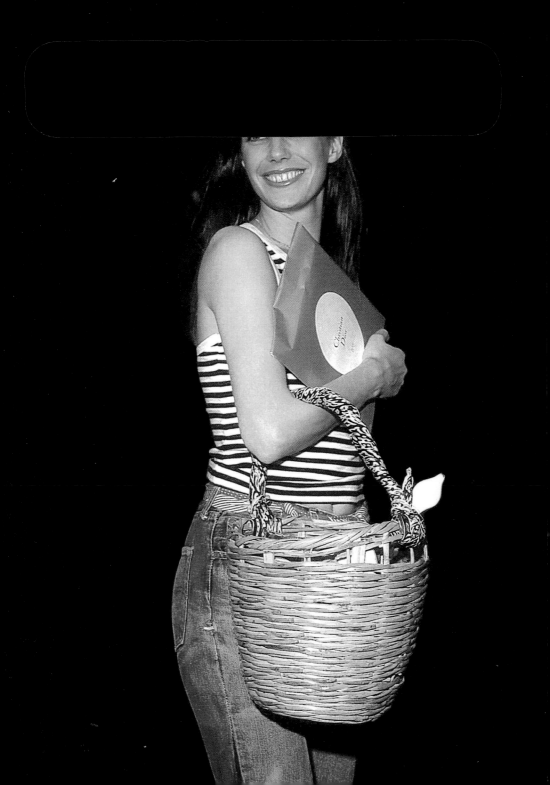

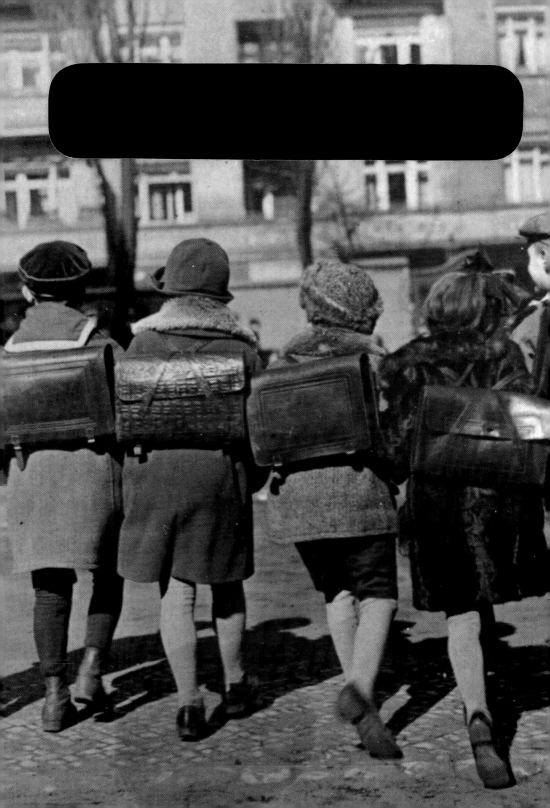

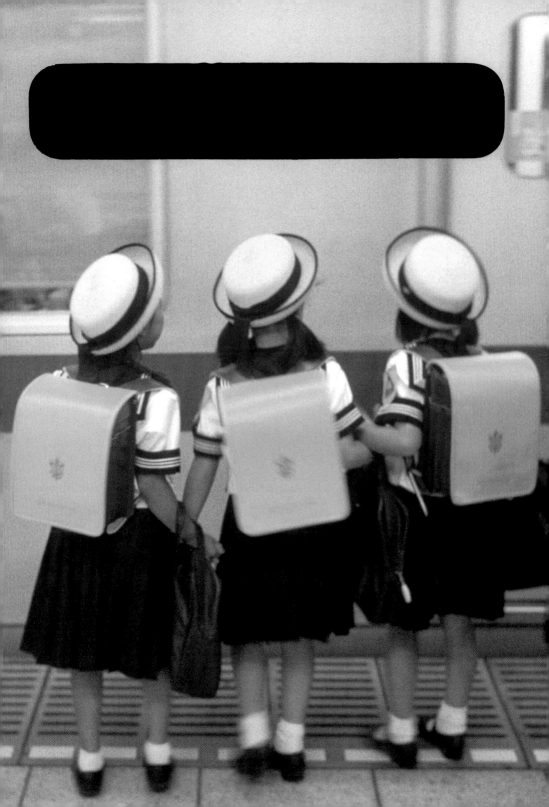

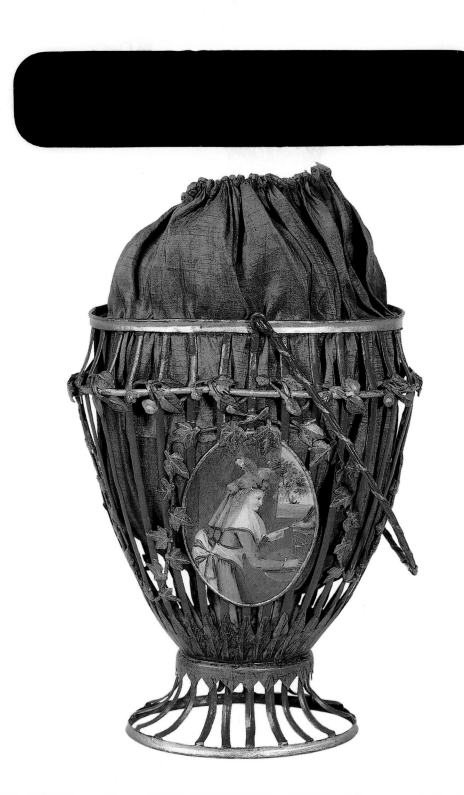

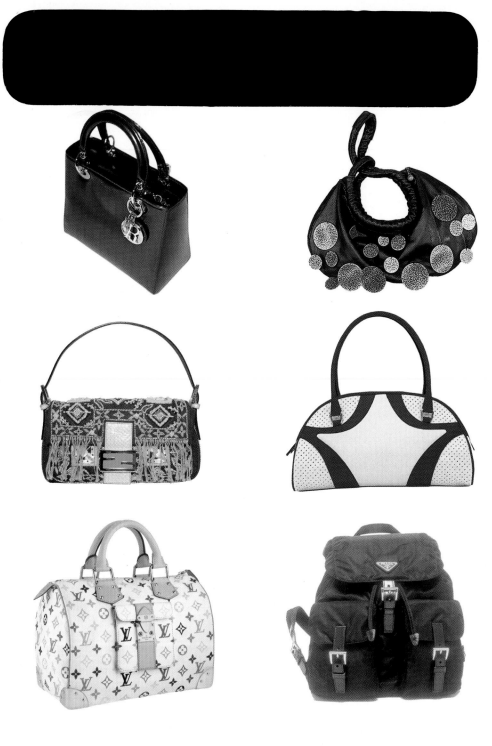

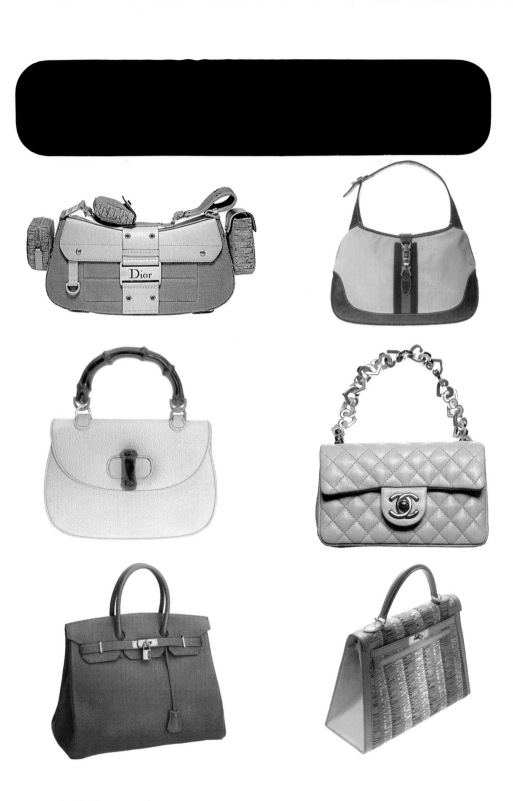

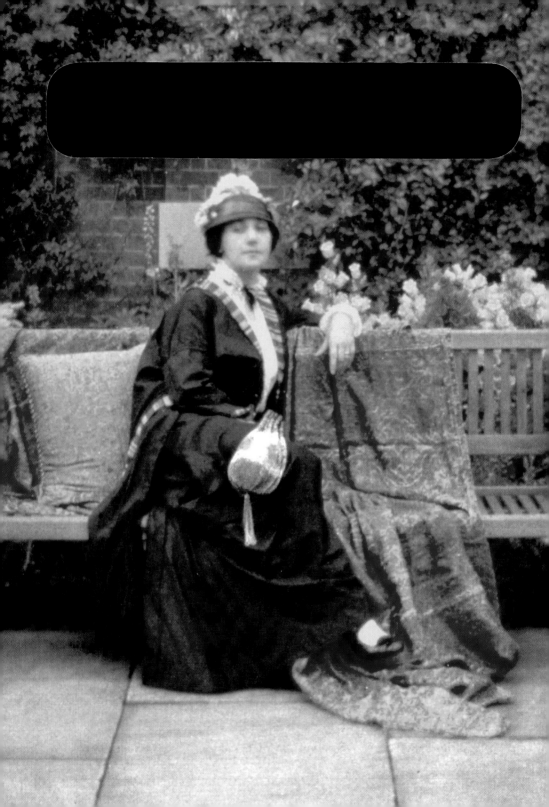

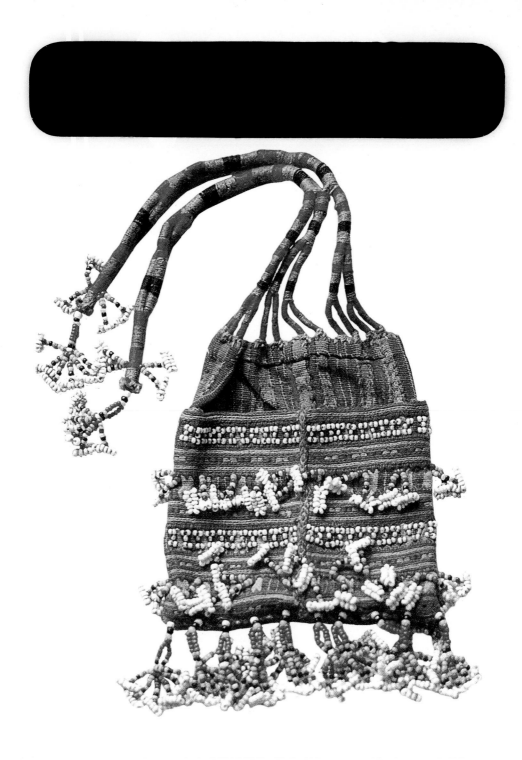

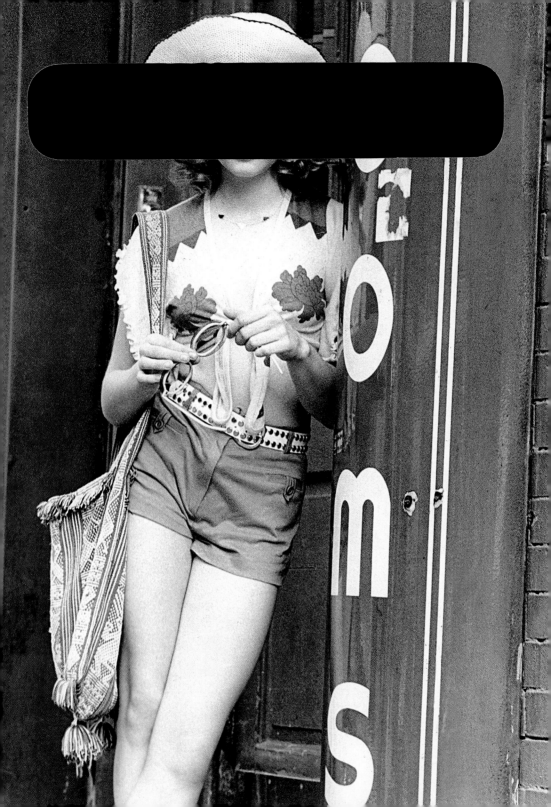

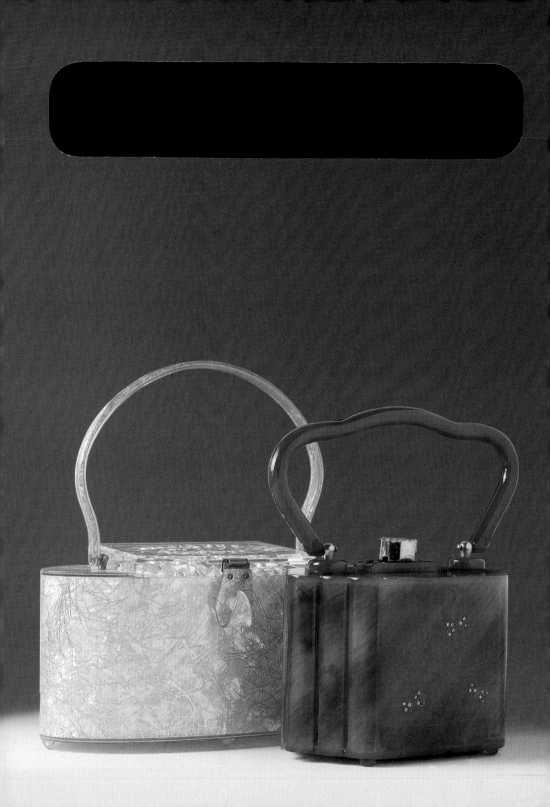

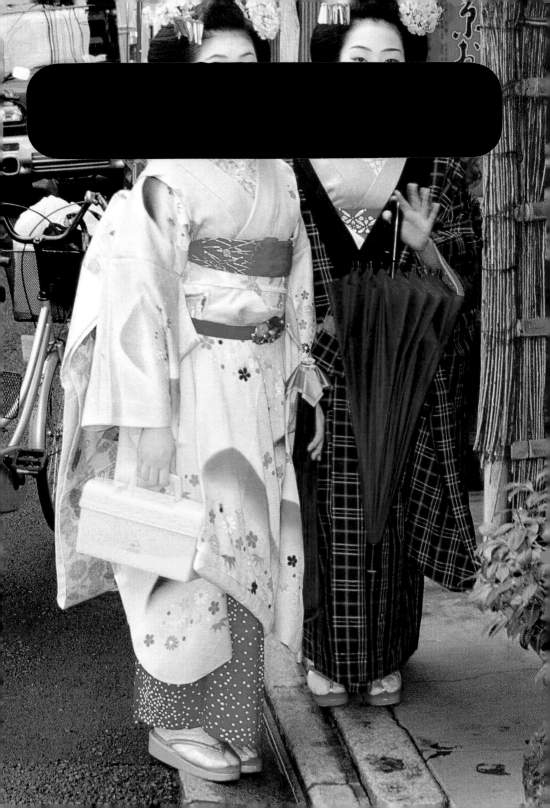

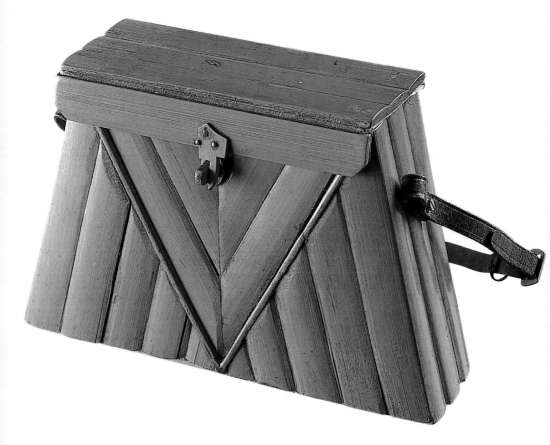

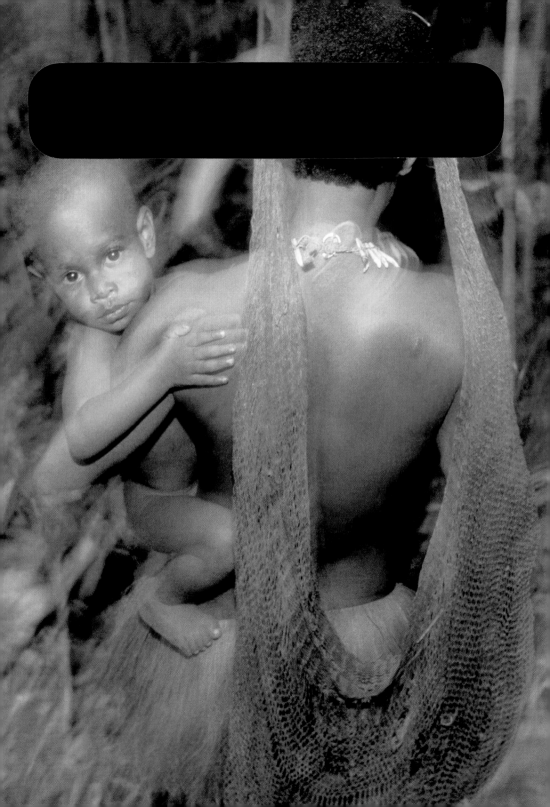

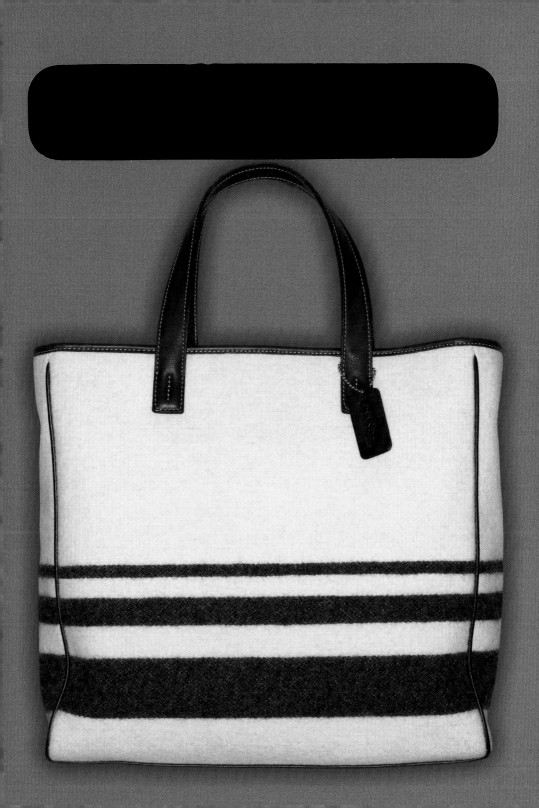

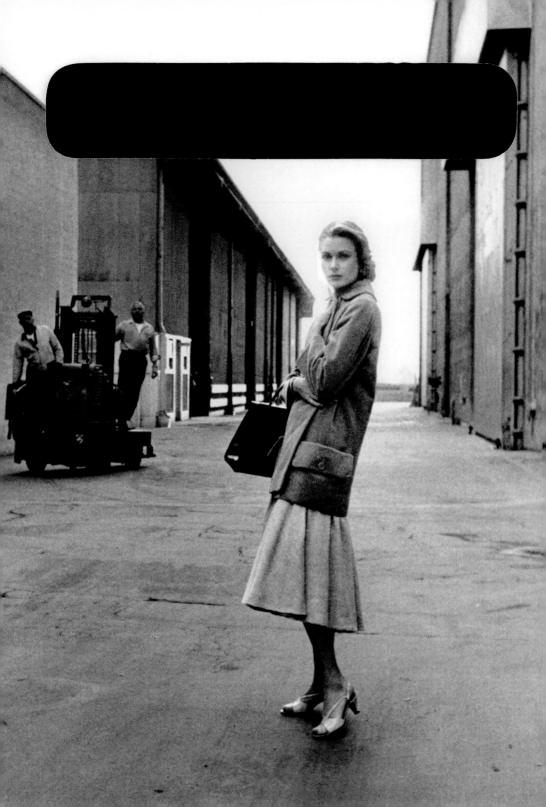

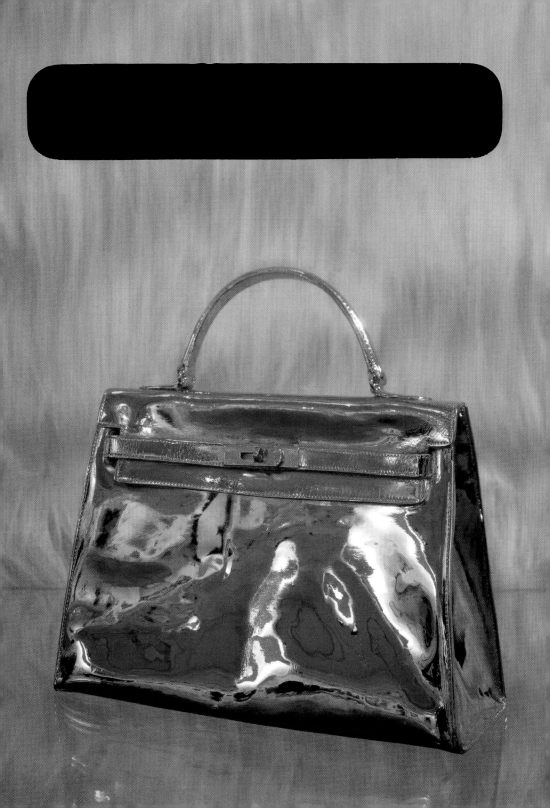

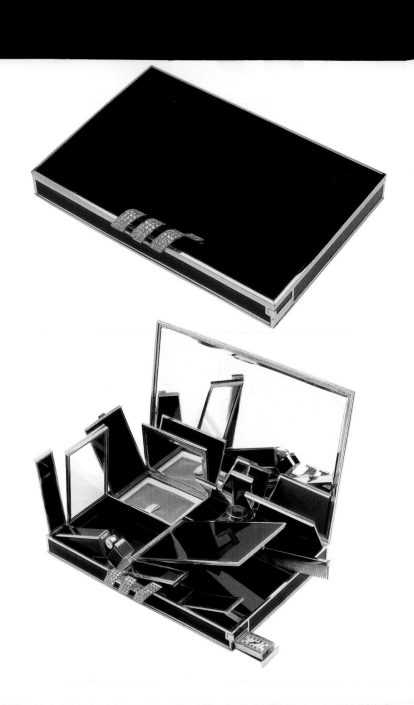

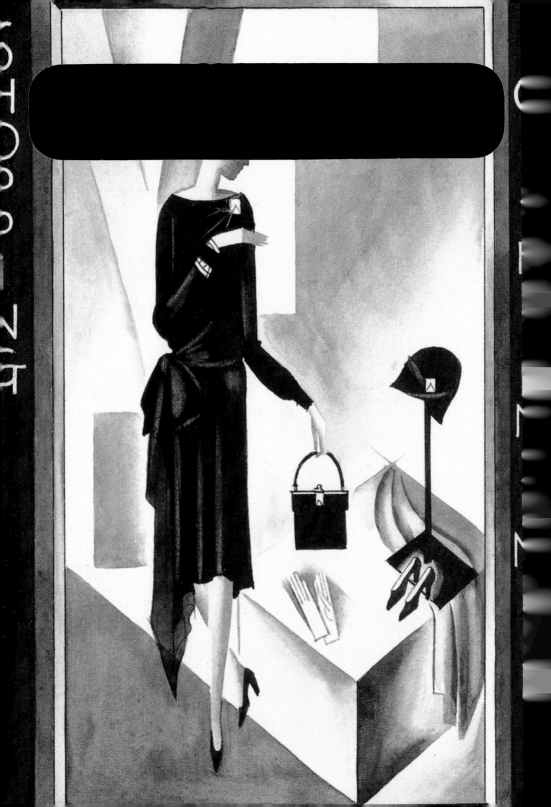

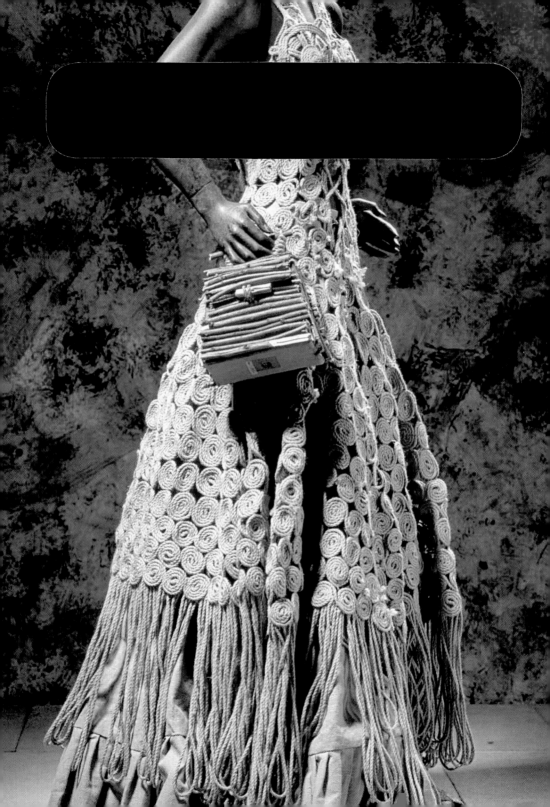

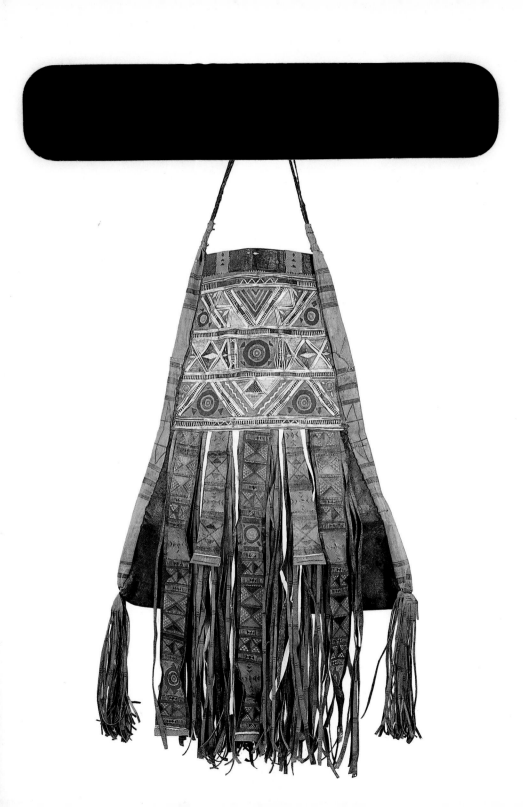

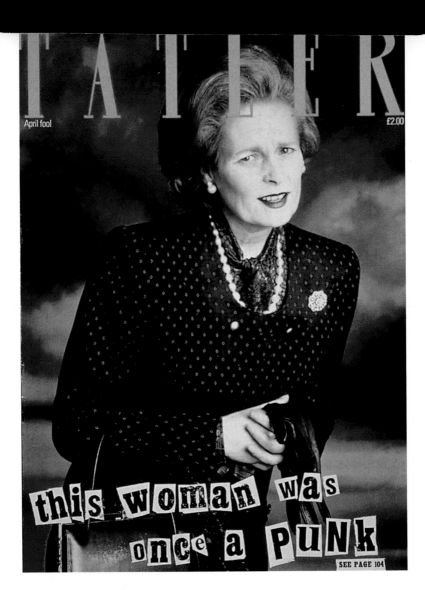

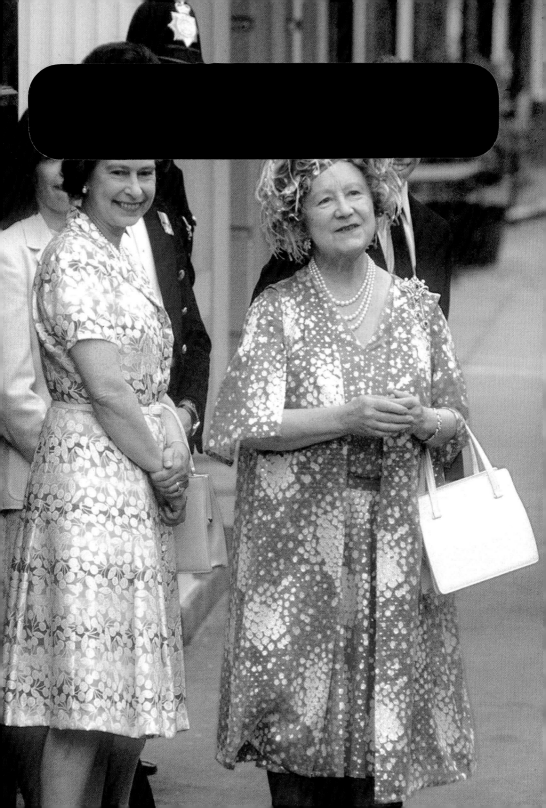

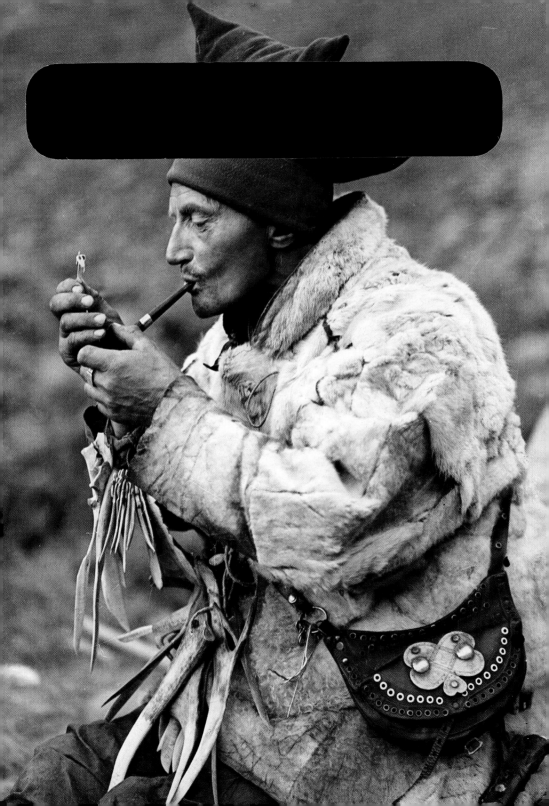

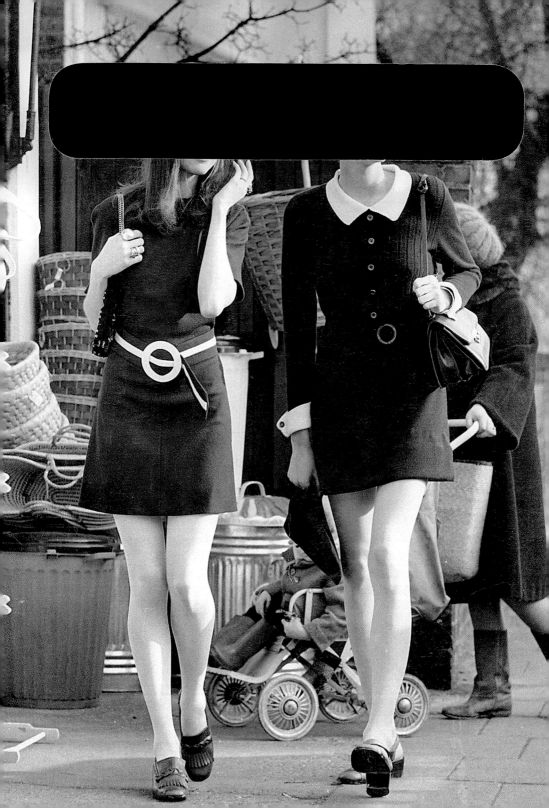

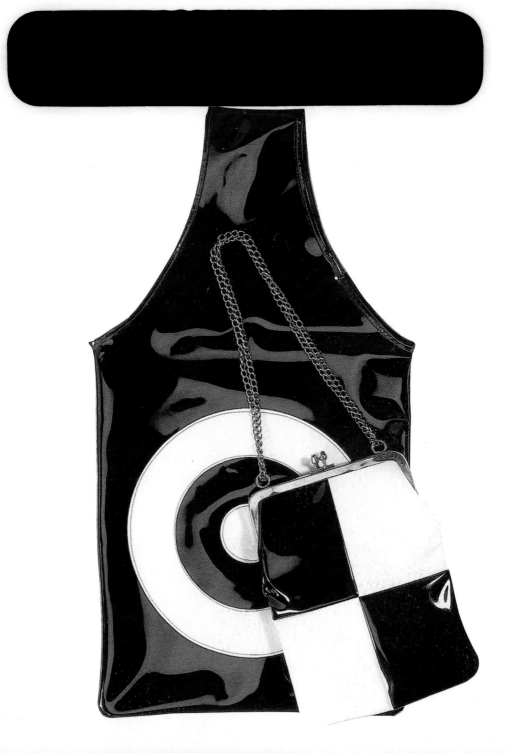

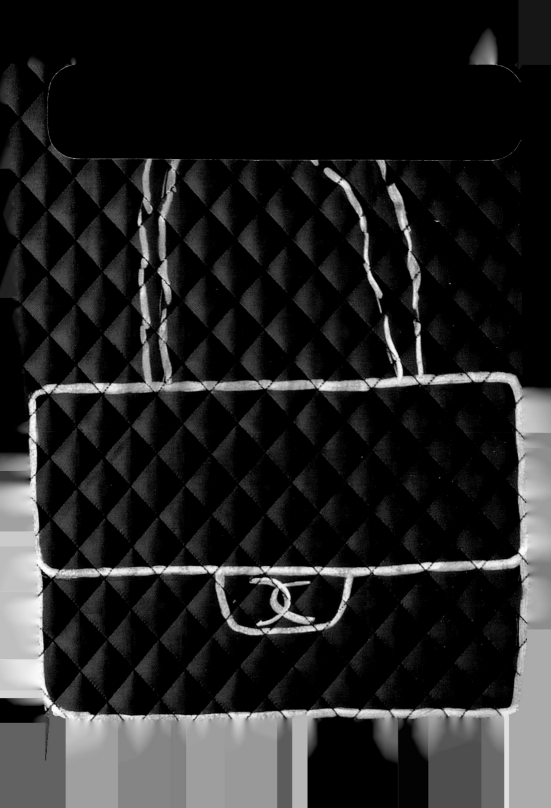

A few dates

1795-1800: The reticule, reminiscent of a Roman lady's mesh bag, emerges. It can be considered the true ancestor of the handbag.

1837: Hermès is founded in Paris, specializing in the manufacture of saddles and harnesses.

1854: The Louis Vuitton luggage and leather goods company is founded in Paris.

1876: The Lancel company is created in Paris.

1896: Louis Vuitton debuts its famous Monogram Canvas.

1913: The Prada brothers found the luxury leather goods house that bears their name in Milan.

1930: Coach is founded in the United States.

1937: Dali designs his famous "telephone bag" for Elsa Schiaparelli.

1938: Elsa Schiaparelli creats the "Lantern" or "Lamppost" bag. Other "object" bags are created including the "birdcage" bag, echoing René Magritte's *Modèle Rouge*, the "flower pot" bag, and the "piano key" bag.

1947: The Italian designer Gucci creates its famous bamboo handle bag made of black calfskin.

1950: In answer to the growing demand for inexpensive bags, plastic bags flood the market in a palette of colors.

1955: The mythical "2.55" is designed by Chanel.

1956: Originally created for the house of Hermès in 1892, the bag previously known as the "small high bag with straps" is baptized the "Kelly" bag in homage to Grace Kelly.

1960: The advent of youth culture. The adoption of the shoulder strap bag signifies from here on liberation and relaxation.

1970: Paco Rabanne designs a bag made of plastic chips held together by metal rings.

1971: The androgynous silhouette return at Yves Saint Laurent with a canvas and leather pouch worn on the shoulder.

1980: The backpack is taken up by everyone from Céline to Salvatore Ferragamo and Chanel to Prada.

1984: Hermès designs the "Birkin" bag for British singer Jane Birkin.

1996: The great British designer Vivienne Westwood designs, for Louis Vuitton, a limited edition "fake fanny pag" in monogrammed canvas.

1998: Chanel creates the "2005" bag.

Design of the Chanel quilted bag, the indispensable accessory created in February 1955.
© Chanel/Photo Laziz Hamani.

2000: Christian Dior revives his leather goods department with his saddle bag. 100,000 are sold in the first year!
Fendi's "Baguette" bag enjoys considerable success.

2002: A bronze sculpture of a "Kelly" bag by the Swiss artist Sylvie Fleury is auctioned off for 18,000 euros by the Tajan firm at Drouot in Paris.

2004 : An exhibition dedicated to the handbag, sponsored by Hermès, is held at the Fashion and Textile Museum in Paris.

A few figures

20,000,000: Number of Japanese women who, in 2002, owned a Vuitton bag.

1,000,000: Number of "Lady Dior" bags sold worldwide since Princess Diana made it fashionable in 1995.

600,000: Number of Fendi "Baguettes" sold between 1998 and 2001.

12,300: Amount in dollars that a three-color crocodile model of the ever-fashionable "Kelly" was auctioned off at Drouot in 2000.

180: Number of steps required to manufacture a "2.55" bag by Chanel: a series of skilled operations that no machine can replace.

A few books

Le Sac à main, histoire amusée et passionnée, Geneviève and Gérard Picot, Paris, Éditions Du May, 1993.
A Century of Bags, Icons of Style in the 20th Century, Claire Wilcox, London, Quarto Press, 1997.
Handbags: A Lexicon of Style, Laird Borelli and Valérie Steele, New York, Rizzoli, 2000.
The Leather Book, Anne-Laure Quilleriet, New York, Assouline, 2004.

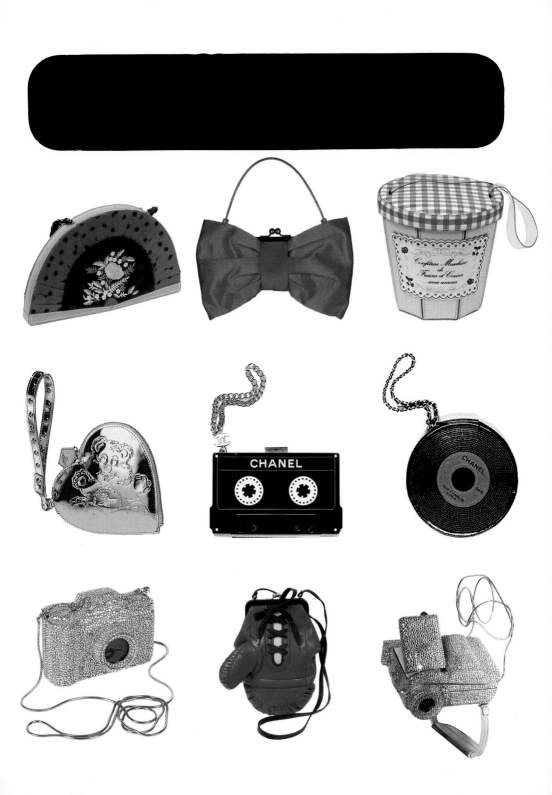

"Saddle Bag," Christian Dior. After the success of the "Lady Dior," which revived the leather goods at Christian Dior in 1995, the 2000 launch of this saddle-shaped bag left behind for good the deliciously "retro" side of the couture house. 100,000 were sold in the first year! © Courtesy Dior.
Fashion of the times, **Antonio Lopez,** 1966. Hair floating in the wind, her bag negligently handing on her shoulder, this young woman ostentatiously shows off her idea of freedom. The psychedelic colors seem to shout "Peace and Love." © Paul Caranicas.

"Stiletto Bag," Rodolphe Ménudier for Goyard. Kidskin bag equipped with a spike heel. © Francesca Alongi. **"The Gloria,"** **Louis Vuitton,** spring-summer 2004. © Jason Schmidt for *V Magazine,* 2004.
Gladly fetishist, full of erotic references, the bag is the best barometer of our animal impulses. The proof is in this "stiletto heel" bag—reminiscent of Buñuel—like this poster with undeniable phallic symbolism, by Louis Vuitton.

Flat bag with pockets, Hermès, 1939, in box, attached to a belt. Carried on the shoulder, this pouch wonderfully reconciles the eternal dilemma between the pocket and the bag. It elegantly symbolizes the first steps of a finally emancipated woman. © François Kollar/Ministère de la Culture France.

Bags from Malaysia and Papua New Guinea. From top to bottom, left to right: Shield with its bag and arrows (Paris, Musée du Quai Branly) © RMN/Berizzi; bamboo basket (Vienna, Museum für Völkerkunde) © Akg-Images/Lessing; two weaved bags (Saint-Germain-en-Laye, Antiquités Nationales) © RMN/Berizzi.
Handbag from the "Gancino" line, Ferragamo, spring-summer collection 1996, strap made of natural wicker. © Courtesy Museo Salvatore Ferragamo. Was the handbag born out the maniacal desire to carry around one's home?

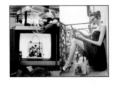

Interior scene at Orly. Far from its upper crust image, Hermès ceaselessly reinvents its assets, oscillating between humor and subversion. "Kelly" x-rayed in an airport. © Daniel Aron.
Transparent bag, Armani, 1995. The transparent bag becomes a true showcase for the purse's contents, considered by most to reveal a woman's personality! © Malena Mazza.

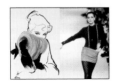

Dress designed for Pierre Balmain by René Gruau, 1952. Close to the body, this fur bag-muff is both a substitute for the pocket and an efficient winter accessory. © Illustration René Gruau/www.rene-gruau.com.
"Bag-dress," Chanel, ready to wear fall-winter 1986. Chanel reverses the process of the "bag-dress": It is the bag itself that becomes the "dress"—or rather "skirt"—in this magnificent model worn by Inès de la Fressange. The gold chains used as straps perfectly finish the signature. © Michel Bechet.

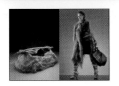

Inuit work bag carried by men. © Peter Harholdt/Corbis.

Model wearing a Hermès dress, kidskin vest, Anne Demeulemeester leather pants, antique gold leather pouch from Céline, Elena Meyer belt, a leather strap tied around the waist by Jean Paul Gaultier, suede and fur gaiters worn with tie-dye denim sandals by John Galliano. Queen of the runway, this "amazon" of modern times borrows from the nomad world and the polar world her fur and a conquering attitude. Model: Elianna/Karin Models. © Vera Palsdottir.

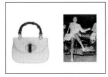

Bamboo bag, Gucci, 1950s. During its years of independence, Italian designer Gucci decided to turn to other materials, creating the famous black calfskin bag with bamboo handles. Later, it will be reproduced in other materials, such as crocodile, lizard, or, as it can be seen here, in white leather. © Courtesy Archives Gucci.

Anita Ekberg, Rome, 1950's. A symbol of sensuality and freedom, the *Dolce Vita* actress poses here with the obligatory accessories of modern times: a car and a shoulder bag. © Olympia Publifoto.

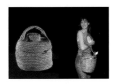

Aborigine woman's bag, Australia, c. 1932, natural fibers. © Art Gallery of New South Wales/Jenni Carter. **Jane Birkin**, 1973. © Olympia Publifoto.
Here, a basket made by an Australian woman, there, an icon of the 1970s, Jane Birkin, elegantly and easily sporting a basket instead of a handbag.

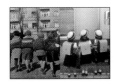

Berlin schoolchildren, 1930s. © Getty/Hulton Archive.
Japanese schoolchildren, Tokyo, 1996. © Harry Gruyaert/Magnum Photos.
Here, the satchels demurely riding on the shoulders of these little Berlin schoolchildren from the '30s; there, those of young Japanese schoolchildren in the Tokyo subway recently. Utilitarian, light, the backpack has become ubiquitous in the four corners of the planet.

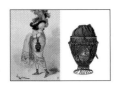

Merveilleuse du Directoire, color lithograph after a drawing by Albert Robida, 19th century. © Akg Images. **"Lovers" bag**, 1794. © Photothèque des Musées de la Ville de Paris.
The true ancestor of the handbag, the reticule owes its name to the *reticulum*, a kind of mesh bag worn centuries earlier by Roman ladies. The caricaturists had a field day ridiculing this new female accessory.

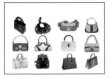

From left to right, and top to bottom: Left-hand page: **Lady Dior, Christian Dior**, 1997 © Dior; **Bambi, Sonia Rykiel**, 2002 © Sonia Rykiel; re-edition of the **Baguette bag, Fendi** © Fendi; **Bowling bag, Prada**, 2000 © Prada; **Speedy 30, Louis Vuitton**, 2003 © Laurent Bremaud/Louis Vuitton; **backpack Prada**, 1984 © Prada. Right-hand page: **Street chic, Christian Dior**, 2002 © Dior; **Jackie O. bag, Gucci**, 1961 © Gucci; **Bamboo bag, Gucci**, 1950s © Gucci; **quilted bag, Chanel**, 2004 © Joseph Benita/SIC; **Birkin bag, Hermès** © Studio des fleurs/Hermès; **Kelly bag, Hermès** © Quentin Bertoux/Hermès.

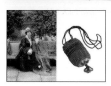

Tamara Karsavina, portrait by Baron Adolph de Meyer, c. 1908, autochrome. © Victoria and Albert Museum, London. **Small handbag belonging to the Empress,** made of silk and steel. Châteaux de Malmaison and Bois-Préau. © RMN/Martin Yann.
Precious and refined, this Second Empire alms purse limits the woman to her role of outmoded fashion plate. This is a long way from the tomboy of the Jazz Age or to the emancipated woman of the '40s!

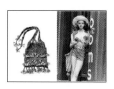

Tobacco pouch, province in Northern Luzon, cotton and glass beads. Photo P. Benitez Johannot. Previously Musée Barbier-Mueller Collection. © Musée du Quai Branly. **Jodie Foster** in the film *Taxi Driver* by Martin Scorsese, 1976. © Columbia/The Kobal Collection.
Kaleidoscope of worlds and images! On one side, the tobacco pouch of a warrior from this remote province of Indonesia, on the other the liberated and hippie look of young American actress Jodie Foster. And yet, in its own way, the fringe bag reinvents the fantasy of the West in serach of easy exoticism....

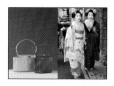

Acrylic bags, United States, 1944. © AKG Images.
Geishas, Kyoto, Japan, 1999. © Chris Steele-Perkins/Magnum Photos.
Fifty years separate these two worlds and these two images. And yet, these "geisha-dolls" seem to hold in their hands the same type of "toy-bags" favored by American women in the '40s. One must say that the latter could easily be mistaken for a small Japanese *inrô* box!

Chinese handbag made of bamboo strips, brass, and leather, Shanghai, '30s. François Dautresme Collection, Paris. © Arnaud Carpentier. **Bamboo pouch** carried by a model, 1938. © Lusha Nelson/Condé Nast Archive/Corbis.
Far-Eastern material par excellence, bamboo adapts to a variety of fashions and customs: western-style in this Chinese bag from the '30s, practical and "fun" in this pouch, nonchalantly sported by an American supermodel.

Monica Vitti in the film *Girl with a Pistol* by Mario Monicelli, 1968. © Lux/Documento/The Kobal Collection. **Woman carrying her child,** Irian Jaya Province, Indonesia, 2000. © Anders Ryman/Corbis.
Different climates, different customs! Here, a shopping bag worn like a handbag, light and manageable, there a headband bag worn on top of the head in this remote Indonesian region, near Papua New Guinea.

Woman wearing a sari, India, 1995. © John Van Hasselt/Corbis Sygma.
"Wool Stripe Blanket Tote," Coach, 1999. © Frederik Lieberath.
Irony of fate! For a long time relegated to the role of practical, if not vulgar, bag, the *cabas* (from the Latin *captivus* or "carryall") has recently been raised to the status of luxury, if not "trendy", with certain couturiers. This model from the prestigious Coach house, all the rage among American women, supermodels or upper crust, is no exception.

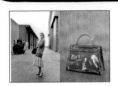

Kelly Bag, Sylvie Fleury, 1998, bronze, 27 x 18 x 18 cm. © Courtesy Art & Public, Geneva. **Grace Kelly** in a Hollywood studio, carrying the famous Hermès bag named after her in 1956. © Magnum photos. On the one side, the Hollywood legend, or how a blonde American actress becomes a princess and lends her name to one of the most coveted bags on the planet, on the other side, the caustic verve of artist Sylvie Fleury raising the celebrated "Kelly" bag to the rank of artwork in a silver-plated bronze version. Or the art of redefining an icon of our frenetic consumer society.

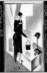

Minaudiere, **Van Cleef & Arpels,** closed and open, 1935. © Courtesy Archives Van Cleef & Arpels. *Shopping for the ensemble,* watercolor by Libiszewski, 1930. © All rights reserved. At the turn of the 1930s, leather goods manufacturers could not meet the demand of elegant women fast enough, who then turned to jewelers. Conventional until then, the bag goes slumming and becomes a minaudiere of a rarely matched luxury. A true "secrets box" with a profusion of compartments. Those signed Van Cleef & Arpels are surely among the most beautiful and sophisticated.

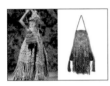

"Red or Dead" bag, 1993, Great Britain, twigs, string, and jute canvas. © Victoria & Albert Museum. **Touareg travel bag,** Sahara, 1931, leather, paint and cotton embroidery. Musée du Quai Branly, Paris. © RMN/Arnaudet.
In England, the same "ethnic luxury" is rampant among designers: natural fibers, full-length fringed dresses.... Like an air of Marrakesh or somewhere else, to escape the gray skies of London and the Thames....

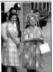

Vivienne Westwood for the cover of *Tatler* magazine, April 1989. © Michael Roberts/ Maconochie Photography. **Queen Elizabeth II** at the fiftieth anniversary of her reign, on February 6, 2002, with the Queen Mother. © Tim Graham/Corbis.
Left, the irreverent humor of the great English designer metamorphosed into Margaret Thatcher, truer than life, nervously clutching her bag, a pitiful symbol of her position. Right, the surreal silhouettes of Elizabeth II and her mother, whose hats are equaled only by their bags.

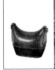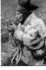

Tobacco pouch, Northern Luzon, province of Ifugao, hardwood. Photo Studio Ferrazzini. Previously Musée Barbier-Mueller Collection. © Musée du Quai Branly. **Man wearing a game bag** on the side and smoking a pipe, Laponia, c. 1900-1930. © Hulton-Deutsch Collection/ Corbis. One often forgets that in many regions of the world, wearing a bag is not reserved for women alone. The proof is this magnificent tobacco pouch with an astonishingly modern design. Dressed warmly, wearing a refined and elegant pointed bonnet, this Laplander sports a studded game bag that would not look out of place at a John Galliano show.

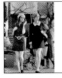

The London of the '60s, 1968. © Roy Jones/Stringer, Getty Images.
Typical PVC handbag of the '60s. © All rights reserved.
The baby-boom generation wants just one thing: to do away with the rigid structures of the old world. Along with the miniskirt, the bag is playful, insolent, light, washable, and especially affordable! Eschewing luxurious leather, plastic is king, a pretext for colors and highly inventive graphic games.

The author would like to thank Martine and Prosper Assouline for their enthusiasm and creativity. Her gratitude goes as well to to Francesca Alonghi for her invaluable iconographic research, as well as to Julie David for her judicious editing. The writing of this book was nourished by the anecdotes that were shared with her by Ménéhould du Chatelle from Hermès, Odile Babin from Chanel, as well as Patrick-Louis Vuitton from the house that bears his name. At the risk of repeating herself, the author thanks with great warmth Denise Geoffroy, Laurent and Cassandre Schneiter for their patience and tender affection.

The publisher would like to thank all those that helped in the making of this book, the photographers and their agencies: AKG (Thomas Pey, Fabienne Grévy), Francesca Alongi, Daniel Aron, Art Gallery of NSW (Alice Livingstone), Michel Bechet, Arnaud Carpentier, Corbis (Thierry Freiberg), Véronique Garrigues (Adagp), Getty (Anouck Baussan, Patricia Lastier, Chrystelle Raignault), Guzman (Corinne Karr), Karin Models, The Kobal Collection, Magnum Photos (Marie-Chistine Biebuyck, Marco Barbon), Malena Mazza, Photothèque des Musées de la Ville de Paris, Olycom Publifoto (Daniela Mericio), Vera Palsdottir, RMN (Maryse Alazard), Jason Schmidt, V&A Images (Rachel Lloyd); as well as the houses, museums and galleries: Cristina Annoni (Moschino), Marion Boucard (Vivienne Westwood), Caroline Boué et Estibaliz Molinos (Sonia Rykiel), Alix Browne (V Magazine/Visionaireworld), Catherine Cariou (Van Cleef & Arpels), Simona Chiappa (Prada), Dominique Clemenceau, Marie Wurry and Serge Muzellec (Louis Vuitton), Coach, Sakura Deguitre (Issey Miyake), Céline Fressart (Art & Public), Marika Genty and Odile Babin (Chanel Conservatoire), Goyard, Christine Maine (Musée du Quai Branly), Cristina Malgara and Daniel Urrutia (Gucci), Laurence Mattet and Petty Benitez-Johannot (Musée Barbier-Mueller), Sylvie Nissen, Anne-Laure Pandolfi (Hermès), Stefania Ricci and Paola Tabellini (Museo Salvatore Ferragamo), Chrystel de Rougemont (Dior), und Ungaro. Finally, it thanks Paul Caranicas, Gérard Dautresme, and Jane Birkin for their kind participation.